British
Portrait Drawings
1600-1900

British Portrait Drawings 1600-1900

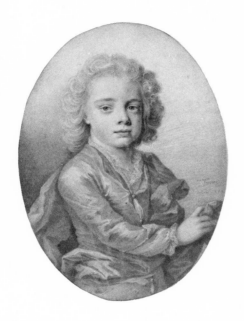

*Twenty-five Examples from the
Huntington Collection*

by Robert R. Wark

THE HUNTINGTON LIBRARY • SAN MARINO, CALIFORNIA

Introduction

PORTRAITS are among the most familiar forms of art; so much so that we seldom stop to think about the many factors that affect our reactions to them. On the most elementary level we respond to the person represented as we respond to someone we meet on the street. Do we like the face, the expression, the hair style, the clothes? Are we attracted to, repelled by, or indifferent to what we see?

But in a portrait we do not see a person face to face; we meet the person through the medium of a third – the artist. All portraitists, including photographers, put some of their own personalities into their works. They select a pose, manipulate the lighting, choose a viewpoint, arrange the objects they include within the picture. These are factors that affect our reaction. Sometimes the artist's decisions in these matters may be determined by his perception of the person portrayed, but often they are the result of the artist's own preferences rather than a response to the sitter. Thus our reaction to a portrait may be at least as much in answer to the artist's personality as to the sitter's.

Many portraits, including all the examples in this booklet, are considerably removed from us in time and place. They involve representations of fashions and manners that prevailed when the portraits were created, and may be very different from those of today. Costume, gesture, pose, setting, even facial expression, are likely to be determined at least as much by the general taste of the time as by the sitter or the artist. Yet these are all factors which may have a profound effect on our response to a portrait.

These three variables (the personality of the sitter, the personality of the artist, the personality of the age) are present in all forms of portraits. Portrait *drawings*, the topic of this booklet, add some special complications of their own. These additional complications arise primarily from the various functions of portrait drawings and the various media in which they are executed.

The term portrait drawing may be applied to works in a wide variety of media, fulfilling many different functions. In this booklet are included works in pencil, pen, wash, pastel, watercolor, and various

combinations and variants thereof. Most of the drawings are executed on paper, although a few are on vellum. Some of them, such as the small portraits in plumbago (pencil) or the relatively large portraits in pastel or watercolor, are self-contained, presentation works of art like oil portraits, although their small physical size and relative fragility mean that they were intended to fulfill a more private and intimate function than life-scale portraits in oil. There are preparatory studies for works of art to be executed in some other medium: engraving or oil. Still others are casual notations made for the artist's own enjoyment or as a record of a memorable face.

The media in which the drawings are executed are often fascinating in themselves, and important factors in our reactions. We are delighted by the precision, control, sharp detail of the plumbago drawings (nos. 3 and 5). We take a different form of pleasure from the free calligraphic elegance of some of the pen drawings (nos. 9 and 13). We admire the skill and economy with which artists working in pastel (nos. 4 and 17) and watercolor (nos. 23, 24, and 25) achieve their effects.

So our response to a portrait, and especially to a portrait drawing, is likely to be a complicated but fascinating mixture of reaction to the sitter, reaction to the artist, reaction to the milieu in which the sitter and artist lived, reaction to the medium and execution, both of which may be determined to some extent by the function of the portrait. There is a comparable blend in the way we react to almost every representational work of art; but because portraits are so constantly with us, we perhaps think less about the ways they affect us than we do about our response to other art forms.

As a specific example consider Harlow's drawing of Mrs. Siddons as Lady Macbeth (no. 20). We know from documentary and other sources that Mrs. Siddons, the most famous tragic actress of her day, had a highly distinctive face, with a notoriously long nose and markedly arched eyebrows. We also know that Harlow, an accomplished society portraitist, drew nearly all his sitters with smooth, porcelain-like skin and liquid, sparkling eyes. The taste of the time in theatrical performances was for more open emotional display in facial expression and action than is normal today. Harlow handles his medium, black and red pencil, with great delicacy and refinement, particularly in delineating the mouth, nose, and eyes. Our total response to the drawing is an amalgam of all these factors: the sitter, the artist, the age, the medium.

Portraiture is the dominant art form in Great Britain from the sixteenth century through the eighteenth. Even in the nineteenth century, when landscape and various forms of narrative art absorb the energies of the most gifted artists, portraits continue to be produced in

quantity. Indeed if we regard the portrait photograph as an extension of the art of portraiture into a new medium, portraiture continues to this day as probably the most frequently encountered of all art forms. People like images of other people, particularly of family and friends.

For the period covered by this booklet, the three principal forms of two-dimensional portraiture found in Britain are the life-scale portrait in oil, the portrait print (usually engraving, etching or mezzotint), and the portrait miniature. Portrait drawings, our concern, can often be related to one or another of these three, although occasionally they have a completely independent existence.

British portrait drawings of the sixteenth century are rarities. Those from the early seventeenth century are scarce, but the quantity increases as the century progresses. The flow becomes fairly steady by the early eighteenth century. The general resurgence in all forms of artistic activity in mid- and late eighteenth-century England greatly augments the quantity of portrait drawings. From then until the present portraits are second only to landscapes in the substantial river of British drawings.

Of the three dominant forms of portraiture – oils, miniatures, and prints – miniatures are the form most frequently and closely related to portrait drawings. Actually there is no clear line separating full-color portrait miniatures from small-scale portrait drawings, although the normal examples of each are different. Portrait miniatures are usually painted on vellum (in the seventeenth century) or ivory (in the eighteenth) in watercolor with some addition of more opaque body color. They are enclosed in richly ornamented lockets, covered with glass, and treated as jewelry. Miniature portrait drawings are usually on paper (although occasionally on vellum). Frequently they are monochrome or very restricted in color. The usual media are wash, pencil, pen, or various combinations of these three. Even the smallest are larger than the normal portrait miniature. They seldom received the locket-like, jeweled setting of a full color miniature. Generally there is a formality, completeness and richness of effect in a full-color miniature that is not present in small-scale portrait drawings. But the drawings have frequently an appeal in medium and technique, particularly the elegance, refinement, and precision of those in plumbago and pen, which gives them an attraction of their own. Nevertheless, the technical means in the portrait miniature and the small-scale portrait drawing are similar; the same artists often created both types. Among the drawings in this book, those by Peter Oliver (no. 1), David Loggan (no. 3), Thomas Forster (no. 5), Richard Cosway (no. 15), John Smart (no. 16) belong to the category of small-scale portrait drawings related to portrait miniatures. It is worth noting in this connection that Oliver,

Cosway, and Smart also created full-color portrait miniatures.

Many portrait drawings are related to prints. Frequently they are studies for prints; occasionally they are copies after prints. This association often conditions the appearance of the drawing in various ways. If the print is in monochrome, the draftsman works out his effects accordingly. If the print is a line engraving, the draftsman is likely to work out his effect in pen or pencil lines. The drawings by Barlow (no. 2) and Vertue (no. 6) are interesting examples of studies for prints. The Barlow, a physically large drawing with a complicated iconographic program, appears to have been an invention of the artist, perhaps working with the assistance of a scholar in devising the learned allusions. The Vertue drawing of Milton, in contrast, is almost certainly a copy of a pre-existing portrait of Milton. Vertue's drawing is a study reducing that portrait to a size and form which he can transcribe into a print. Rowlandson's caricature portrait of J.C. Bach and C.F. Abel (no. 13), although probably not originally conceived for transcription into a print, lent itself readily to that development because of the clean pen lines with which it is constructed.

The relations between portrait drawings and life-scale, oil portraits are more complicated. It might be expected that portraitists in oil would use drawings extensively as a means of working out various facets of their paintings: the details of physiognomy; matters related to pose and costume; the general composition. Such drawings certainly exist. In this book the drawings by Dahl (no. 7) and Fuseli (no. 14) are detailed studies of faces to be subsequently incorporated in oil portraits; the drawings by Ramsay (no. 10) are trials exploring the expressive and other possibilities of various poses for the sitter; the drawings by Thornhill (no. 8) and Mortimer (no. 12) explore problems of arrangement and composition for group portraits to be executed in oil. But it is noteworthy that many of the best-known British portraitists in oil – Reynolds, Gainsborough, Raeburn (to mention only three of the most conspicuous) – seldom use portrait drawings as preliminary studies for oil paintings.

Occasionally portrait draftsmen attempt to achieve in a drawing medium an effect comparable to the color and richness of oil. This happens frequently with pastels. The drawings by Greenhill (no. 4) and Gardner (no. 17) here reproduced are definitely under life-size and more restricted in color range than the normal oil portrait. But they aim for a general richness and completeness of effect comparable to an oil painting. They differ from oils in that the pastel medium, when handled with skill and understanding, has a sketchy, light, airy character beside which most oils seem relatively opaque and heavy.

The full watercolor portrait (as seen in the nineteenth-century exam-

ples by Davis [no. 23], Richmond [no. 25], and Hunt [no. 24]) also aims at a completeness comparable to an oil portrait. Once again the scale is usually much under life size, and the medium (especially in the hands of someone like Richmond) has a lightness and dash that can be matched in oil only by the most virtuoso performer.

A few drawings in this book resist any connections with presentation life-scale oil portraits, portrait miniatures, or portrait prints. Vanderbank's sketch (no. 9), like Rowlandson's (no. 13), might have been transposed into a print. But the cursive, pulsing, calligraphic pen line is essentially drawing, and does not point beyond itself to any other form of portrait. Downman's broad, decisive strokes with black stump (no. 18) might have been captured in oil by Raeburn; but they are a form of drawing rather than painting even if the medium could be oil. Sandby's charming sketch of a lady playing a harpsichord (no. 11) is as much a figure study as a portrait, a record for the artist's own pleasure that aspires to nothing more than it is. Smetham's searching and disturbing self-portrait (no. 21) is probably also a record made by the artist with no thought of relating it to one of the more formal types of presentation portraits.

If portrait drawings considered as portraits tend to align themselves with other forms of portraiture – the life-scale oil, the portrait miniature, and the portrait print – portrait drawings considered as drawings have a coherence of their own. Some of this coherence comes from simple physical facts: most drawings are on paper and most of them are of cabinet (that is, small to middling) size. More important is the coherence that comes from media and the ways the artists use those media. There is variety in the media – pen, pencil, monochrome wash, watercolor, pastel – but the artists use all of them in ways that invite us to enjoy and savor the control they have over them. Of course this invitation exists to a degree in all works of art, but it is especially conspicuous in drawings. In drawings, more than other art forms, the spectator feels close to the artist, watching him work out an idea (as in no. 10), sensing his control (no. 3) or freedom (no. 25) in handling his medium, becoming familiar with the highly personal handwriting or calligraphy (no. 9) with which he constructs his forms. Portrait drawings share with other types of drawings a sense of intimacy normally less apparent in life-scale oil portraits, formal portrait miniatures, and portrait prints.

The twenty-five examples illustrated in this booklet have been selected from the large group of British portrait drawings in the Huntington collection to demonstrate the quality of British achievement in the field, the variety in types, and the fascinating complexity in appeal.

List of Drawings

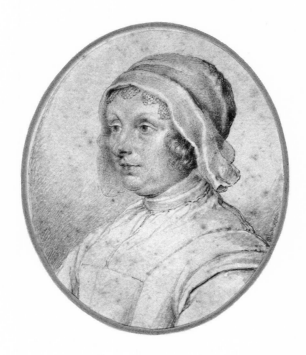

1. **Peter Oliver** (c. 1594-1647)

Peter was the eldest son of Isaac Oliver and, like his father, was primarily a miniaturist. Peter executed miniature narrative pictures and copies after old masters as well as portraits.

Portrait of a Lady (Mrs. Oliver?)

> Pen and brown ink with brown wash on paper;
> 3½"x2¾" (90cm.x70cm.), oval
>
> Acquired: 1963 (63.52.161)

Oliver's miniature portraits are usually in the normal form for the time: highly finished, in full watercolor with body color, on vellum, enclosed in a locket. This monochrome miniature on paper, although of great delicacy and refinement, is more freely drawn than those in full color. It is an informal, and hence more personal and intimate technique which Oliver used in a self-portrait and three other portraits of what appear to be the same woman. One of these is identified by an inscription as the artist's wife. (See Robert R. Wark, *Early British Drawings in the Huntington Collection*, San Marino, 1969, p. 37.)

2. **Francis Barlow** (1626?-1704)

Barlow was a painter (primarily of animal and sporting subjects) and a printmaker. His drawings, most of which are preliminary studies for prints, are among the most esteemed and attractive produced in seventeenth-century England.

Emblematic Portrait of Oliver Cromwell

Pen and black ink with gray wash; verso treated with red pencil for tracing; many of the outlines scored by tracing; 22½″ × 16¾″ (57.2cm. × 42.6cm.).

Acquired: 1951 (in Bull's Granger, gift of Estelle Doheny) (64.14)

Note: An engraving, the reverse of the drawing, with several variations and added captions, appeared in 1658 under the title "The Embleme of Englands Distractions." The print is usually attributed to William Faithorne.

This large and complicated drawing is an example of emblematic portraiture. Cromwell is surrounded by figures, scenes, and devices which symbolize his achievements. The print based on this drawing has added captions which help to clarify the meaning, although many details remain obscure. Cromwell is presented as the champion who has brought Britain through trials and tribulations to peace and prosperity. He has safely piloted the ship of state through treacherous waters. The state now rests, like the ark after the flood, on Mt. Ararat, while the Dove returns with the olive branch of peace in its beak. Cromwell's faith in the Divine Will (like that of Abraham sacrificing Isaac) has contributed to the successful outcome. He has used his military prowess to maintain the unity of England, Scotland, and Ireland, to stamp out faction and error, and to preserve the church from the inroads of Roman Catholicism (symbolized by the Whore of Babylon). But now these various crises are past; the spears have become pruning hooks; the swords have become plows; the bees are making their hive in the helmet. Oliver has brought the olive branch of peace to the land.

The meaning of some of the symbols remains uncertain. The group working with pickaxes below the pillar supporting the church and state may refer to surreptitious activities against the government, such as the Gunpowder Plot, traitorous acts which end at the gallows. The two clerics with a lantern may also refer to clandestine operations on the part of the Roman Catholic Church.

Portraits with such an elaborate iconographic program as this drawing are rare in English art, although Reynolds's painting of *Mrs. Siddons as The Tragic Muse* (1784) is almost as complicated.

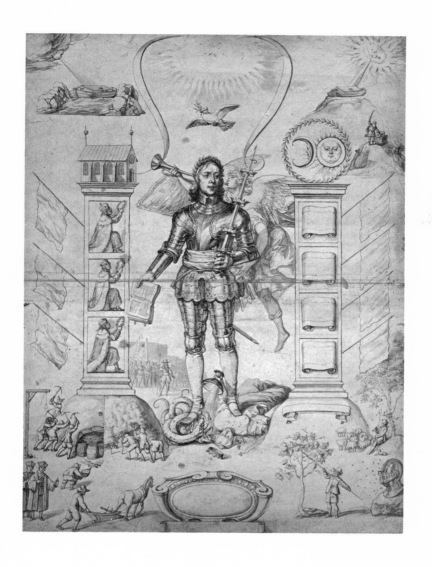

13

3. **David Loggan** (1635-1692)

Although Loggan was born in Danzig and received his artistic training on the Continent, he was of Scottish descent. He came to England in the late 1650s and was active as a topographical and portrait draftsman.

Portrait of a Lady

Black lead on vellum, the face touched with a light, yellow wash;
5¹³⁄₁₆″ × 4¾″ (14.8cm. × 12cm.), oval.

Signed with initials and dated: D.L. 166- [last digit obliterated].

Acquired: 1963 (63.52.136)

Loggan is one of the earliest and most accomplished practitioners in England of a type of miniature portrait drawing usually executed in black lead (called plumbago) on vellum. This portrait is a splendid example of his work.

Plumbago portraits originated on the Continent but enjoyed considerable popularity in England during the late seventeenth and early eighteenth centuries. At their best they have a precision, delicacy, and elegance of execution which make them among the most seductive of British portrait drawings. The appeal is enhanced by the characteristics of the graphite medium and vellum support, both of which give a sensuous softness to the surface.

We do not know who is represented in this drawing. At one time the sitter was said to be Oliver Cromwell's mother. But the face does not closely resemble established portraits of Elizabeth Cromwell. The date of the drawing also argues against any connection with Cromwell's mother, who died in 1654.

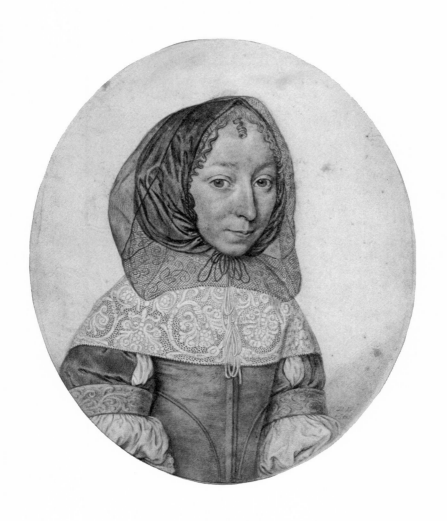

15

4. **John Greenhill** (c. 1640-1676)

Greenhill was regarded by his contemporaries as Lely's most gifted pupil. He did portraits in both oil and pastel. His active career is only about a decade, and his works are rare.

Countess of Gainsborough

Pastel, 9⅞" × 7½" (25.2cm. × 19.1cm.)

Signed, indistinctly, with initials and dated 1669

Acquired: 1963 (63.52.90)

Pastel portraits appear in England during the late seventeenth century with Lely and his school. Early examples, such as this one by Greenhill, use a limited range of color. By the last quarter of the century full color was normal. The taste for pastel portraits ebbed in the first couple of decades of the eighteenth century, but returned in force about 1740 and endured until about 1800.

Greenhill's light, sketchy effect is interesting to analyze. He works on a buff paper with black, white, and red chalk. By skillfully blending these four colors, especially in the face, he achieves a remarkable effect of hue and tone gradation without the heaviness that characterizes many late seventeenth-century full color pastels.

The lady represented in this pastel was Elizabeth, daughter of Thomas (Wriothesley), 4th earl of Southampton. She married Edward Noel in May 1661. He was not created earl of Gainsborough until 1682.

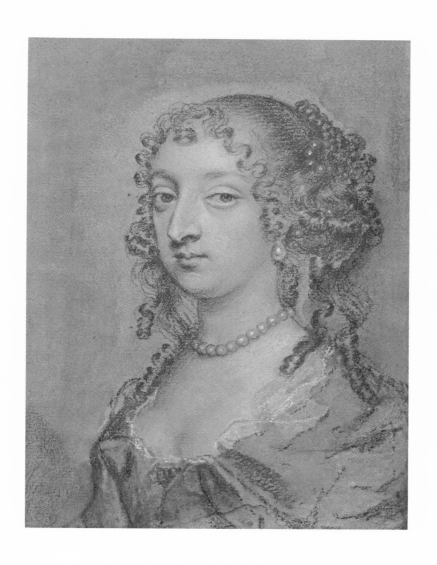

5. **Thomas Forster** (born about 1677, working until after 1712)

Almost nothing is known about Forster, who is visually one of the most ingratiating of the miniaturists working in plumbago. (See no. 3)

Portrait of a Boy

> Black lead on vellum, 4⅞" × 3⅝" (12.3cm. × 9.2cm.), oval
>
> Signed and dated: T. Forster delin 1703
>
> Acquired: 1974 (74.26)

It is interesting to compare Forster's drawing with Loggan's of about forty years earlier. Loggan has applied a light wash to the face; otherwise the technical means are essentially the same. Both men are consummate craftsmen, but they aim for different visual effects. Loggan suggests a rich variety of textures and intricate detail, but the basic shapes and contours are simple and clear. Forster's picture is full of fluttering, crinkled drapery that creates a broken-up, animated surface of light and shadow. In this respect Forster's portrait belongs to the rococo style, which was dominant all over Europe, and especially in France, during the first half of the eighteenth century. Forster is in the vanguard of this developing style. He may, perhaps, have had some contact with early eighteenth-century French portraiture, such as that by Largillière.

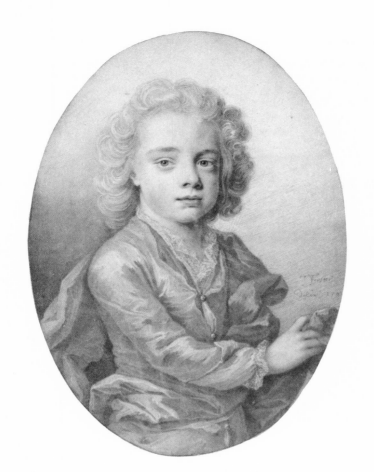

6. George Vertue (1684-1756)

Vertue was a prolific portrait engraver, but is now remembered primarily for his voluminous notebooks, which are an important source of information concerning English art and artists of the seventeenth and early eighteenth centuries.

John Milton

Pen and wash on paper mounted on canvas;
7⅝″ × 6½″ (19.4cm. × 16.5cm.), oval

Acquired: before 1927 (60.6A)

Note: Vertue used the drawing as the basis for his engraving of Milton issued in 1725 in his series "The Twelve Poets"

This drawing is of greater interest as an historical document than a work of art. George Vertue made several portrait engravings of Milton, the two most important being one in 1720 as the frontispiece to Tonson's edition of the *Poetical Works,* and one in 1725 for the series "The Twelve Poets." The earlier engraving is derived directly from Faithorne's famous print of 1670, of which it is a reverse image. The 1725 engraving is based on the drawing now in the Huntington collection. The problem is to determine what Vertue was copying when he made the Huntington drawing.

The problem is of interest because on August 10, 1721 (between the execution of the 1720 and 1725 engravings) Vertue visited Milton's one surviving daughter. He showed her several portraits of her father. His remarks on the interview in his notebooks (*Walpole Society,* 28 [1930], 79) are loosely phrased and subject to different interpretations. Presumably he was seeking her advice in selecting the best likeness of her father. In any event, for Vertue's 1725 engraving he chose a source other than Faithorne's 1670 print.

Of the known portraits of Milton the only one close enough to the Huntington drawing to have any claim to be Vertue's source is a pastel now at Princeton (see John Rupert Martin, *The Portrait of John Milton at Princeton and its Place in Milton Iconography,* Princeton University Press, 1961). Unfortunately there are several minor but significant differences between the Huntington drawing and the Princeton pastel which make it impossible to say definitely that the former was copied from the latter (see Robert R. Wark, *Early British Drawings in the Huntington Collection 1600-1750,* The Huntington Library, 1969, p. 55). Perhaps the Princeton pastel and the Huntington drawing were derived independently from some lost or unlocated portrait. Thus the Huntington drawing is an important document in Milton iconography.

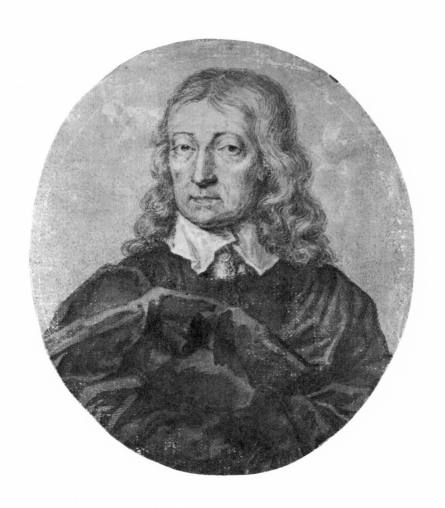

21

7. **Michael Dahl** (1659?-1743)

Dahl, an artist of Swedish birth, became Kneller's principal competitor as a portraitist during the late seventeenth and early eighteenth centuries.

Head of a Boy (attributed to Dahl)

> Black chalk heightened with white on blue-gray paper;
> 13⅞″ × 10⅛″ (35.3cm. × 25.8cm.)
>
> Acquired: 1963 (63.52.115)

The concentration on facial features, the unfinished peripheral areas of the picture, the sketchy execution, all suggest that the drawing is a study, perhaps for a portrait in oils. British portrait painters in oils did not generally make preliminary studies. When such studies exist they are likely to be a trial for pose or composition (see nos. 8, 10, 12) rather than for facial features. Presumably any preliminaries on this last score were worked out directly on the canvas. Sketches such as this drawing, because of their tentative character, often possess a spontaneity and directness which may be refined away in the more carefully elaborated portrait in oil.

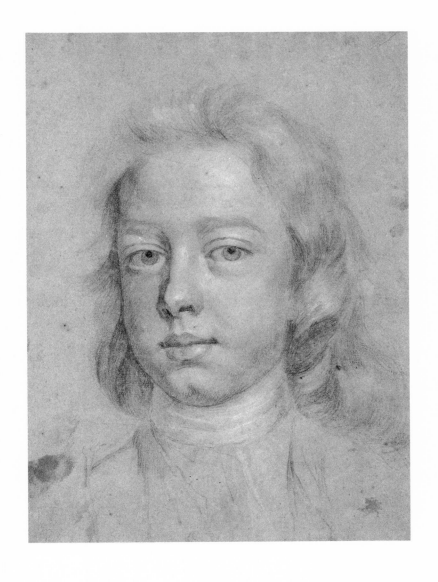

23

8. **Sir James Thornhill** (1675/6-1734)

Thornhill was the major English exponent of the late baroque style of decorative mural painting. He was also Hogarth's father-in-law.

Study for a Portrait of Arthur Onslow

Pen and brown wash; 6½" × 5¼" (16.5cm. × 13.4cm.)

Acquired: 1963 (63.37)

This study, in contrast to Dahl's of a face or Ramsay's of a body position, is an exercise in establishing the whole arrangement or composition of a portrait. The drawing is related to a painting by Thornhill and Hogarth of "The House of Commons," probably commissioned by and featuring Arthur Onslow, who was then Speaker of the House.

Thornhill evidently enjoyed working through the various combinations of the elements that were to be included in a picture. The Huntington has, for instance, a sheet of studies in which he sketches thirteen different arrangements depicting the Biblical subject, "Susanna and the Elders." Several other variations on the Onslow subject are known: in the British Museum, the Yale Center for British Art, and a sheet with four possible compositions which was with the London art dealer, Colnaghi, in 1948.

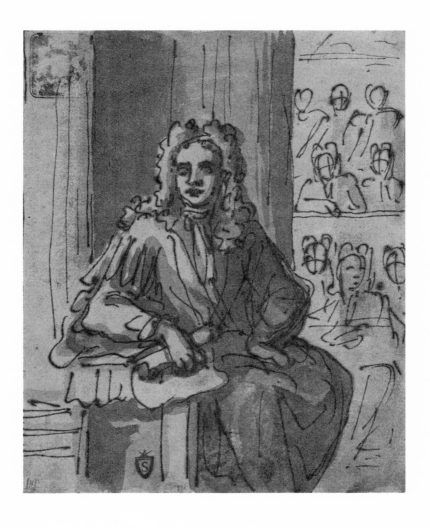

9. **John Vanderbank** (1694-1739)

Vanderbank is known primarily as a portraitist active in England during the 1720s and 1730s. He is also remembered as an illustrator, particularly of *Don Quixote.*

Portrait of a Man (Self-portrait?)

>Pen and brown ink; 11¼" × 7⅝" (28.6cm. × 19.4cm.)
>
>Signed with initials and dated 1738
>
>Acquired: 1970 (70.152)

This drawing is a virtuoso performance with a pen. In contrast to the careful control of an artist such as Peter Oliver, Vanderbank delights in using his pen with obvious dash and freedom. He varies the pressure on the reed so that the line thins and swells, helping to model the head in three dimensions, and also giving the drawing an appeal akin to that of spirited calligraphy; the eloquent squiggles not only suggest a face and figure but also take on a life of their own.

There is no documentary support for the suggestion that this drawing may be a self-portrait; but the intensity of the gaze and the freedom of handling accord with this idea.

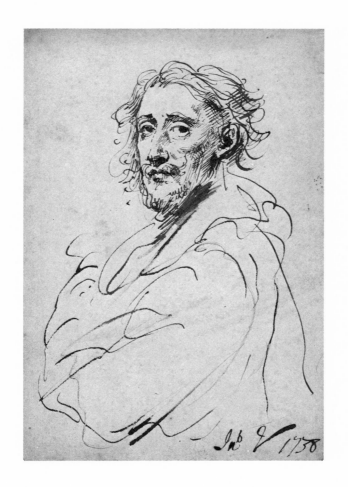

10. **Alan Ramsay** (1713-1784)

Ramsay, of Scottish birth, studied painting in Edinburgh, London, and Rome. He was one of the leading British portraitists during the middle decades of the eighteenth century.

Two Drawings of an Artist (Self-portraits?)

> (a) Red and black pencil;
> 10⅜" × 7½" (26.3cm. × 19cm.)

> (b) Black pencil heightened with white, some wash;
> 10½" × 7½" (26.7cm. × 19cm.)

> Acquired: 1963 (63.52.198 and 63.52.199)

Ramsay was more inclined than most British portraitists to make preliminary studies for his oil portraits. In these two drawings, apparently of the same man at about the same time, he experiments eloquently with pose and gesture as means of varying the mood and expression of a portrait. The drawings – tentative, rapid sketches, even with some details (the hand in [a]) superimposed – provide an intimate and revealing record of the way an artist's mind and eye grapple with a pictorial problem.

The first of the two drawings is related to Ramsay's self-portrait in oil belonging to Sir Ilay Campbell.

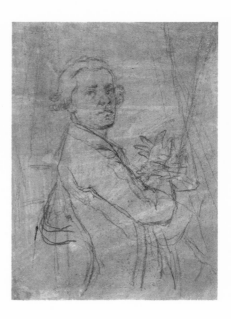

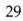
29

11. **Paul Sandby** (1730-1809)

Paul Sandby, known primarily as a topographer and landscapist, was also an attractive figure draftsman. He was a founder member of the Royal Academy.

Mrs. Eyre at a Harpsichord

Red chalk; 7⅜" × 5⅝" (18.7cm. × 14.4cm.)

Inscribed: 3 [upper right] F [lower left]

Acquired: 1959 (59.55.1144)

Note: A version of the subject in watercolor is in the Royal Library at Windsor (see A.P. Oppé, The Drawings of Paul and Thomas Sandby . . . at Windsor Castle, *London, The Phaidon Press, 1947, no. 283)*

In the mid-eighteenth century British artists sought various ways to increase both the decorative and dramatic interest of portraits. One popular solution was the "conversation piece" group portrait (see no. 12). Another, closely related, was the small-scale, full-length figure shown in some form of action. Both types of portraits merge into scenes of everyday life, where the portrait element ceases to be dominant. In this charming drawing, for instance, Sandby is at least as much interested in exploring the pictorial problem of a woman in a handsome dress seated at a harpsichord as he is in telling us anything in particular about Mrs. Eyre. In fact, we know nothing about the lady except her name. She was presumably an acquaintance of the artist.

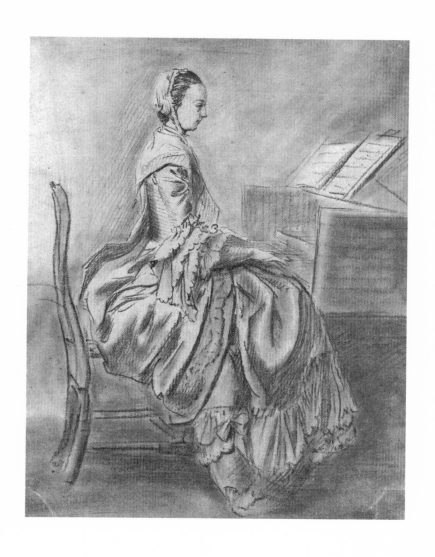

12. **John Hamilton Mortimer** (1740-1779)

Mortimer – narrative painter, portraitist, draftsman, printmaker – was an influential artist in the vanguard of English romanticism.

Study for a Group Portrait, possibly the Drake Family

Pen and gray wash; 7¼" × 9⅜" (18.4cm. × 23.8cm.)

Acquired: 1976 (76.9)

A type of group portrait known as a "conversation piece" enjoyed great popularity in mid-eighteenth century England. Normally a conversation piece included several figures (friends or members of a family) represented at full length but considerably under life size, engaged in some informal activity – playing cards, making music, fishing, or simply talking to one another. The conversation piece offered an opportunity to develop a painting more decoratively and emotionally interesting than the average head and shoulders portrait.

The heyday of the conversation piece in English art is the second quarter of the eighteenth century. Mortimer's drawing, which probably dates from the mid-1770s, is a late example, although conversation pieces continued to be produced well into the nineteenth century. The Huntington drawing has often been considered a preliminary study for one of Mortimer's most important group portraits, *The Drake Family of Shardeloes*. There are, however, many differences between the drawing and the painting; the latter contains more figures, but no baby and only two women.

Mortimer is an early master of line drawing in England. In this respect he influenced a whole group of English draftsmen, including Rowlandson, Blake, and Flaxman.

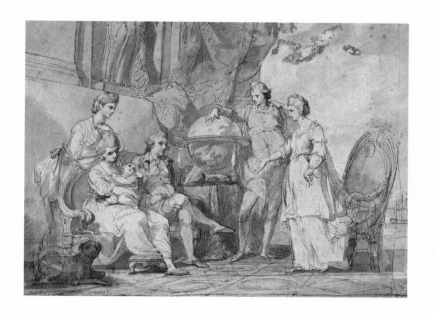

13. **Thomas Rowlandson** (1756/7-1827)

Rowlandson is the leading British comic artist of the late eighteenth and early nineteenth centuries. He is also one of the foremost masters of line drawing in British art.

Caricature Portraits of J.C. Bach and K.F. Abel

Pen and watercolor over pencil; 7⅞" × 6⅝" (20cm. × 16.8cm.)

Inscribed: Concerto Spirituale/Messrs. Boch [sic.] & Abel

Acquired: 1959 (59.55.1099)

The subjects of this caricature are Johann Christian Bach (1735-82), the eleventh son of Johann Sebastian, and Karl Friedrich Abel (1725-87). Bach and Abel, two of the leading musicians of their day, gave highly successful and fashionable concerts together in London from 1765 to the early 1780s. Gainsborough's superb full-length portrait of Abel, his close friend, is in the Huntington Main Gallery. Rowlandson's caricature, on stylistic evidence, probably postdates the deaths of both men.

Caricature, the expressive exaggeration of some facial or bodily feature, usually for comic effect, makes occasional appearances in European and Oriental art from antiquity onward. The emergence of portrait caricature as a developed, independent art form occurs in eighteenth-century Italy. It quickly spread all over Europe. The British adopted it with enthusiasm, and were among the first to exploit caricature for political purposes.

Line, particularly pen line, is an ideal vehicle for caricature. Rowlandson, a great master of pen drawing, is particularly successful in using the medium for caricature. He frequently combines his pen work with pretty, pastel watercolor, giving his caricatures a distinctive bitter-sweet flavor.

14. **Henry Fuseli** (1741-1825)

Fuseli was born in Zurich, trained as a painter in Rome, but active for most of his career in England. His work – inventive, theatrical, learned – is in the vanguard of not only British but European romantic art.

Johann Jakob Bodmer

Pencil; 17¾" × 12½" (45cm. × 31.7cm.)

Acquired: 1964 (64.7)

Note: The drawing is a preliminary study for Fuseli's double portrait of himself with Bodmer, painted 1778-79. Bodmer, a native of Zurich and a leader in the popularization of English literature in Germanic countries, was a great intellectual influence on Fuseli.

This drawing is a brilliant example of the use of lines and contours for expressive characterization. Fuseli delineates the features emphatically and with precision. His approach is particularly evident and eloquent around the eyes and eyebrows. He enlarges the eyes slightly and exaggerates the depth and bushiness of the brows. The effect is to emphasize the meditative and intellectual sides of the sitter's personality.

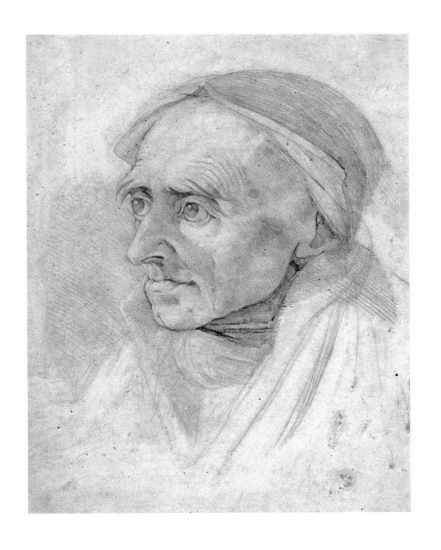

15. **Richard Cosway** (1742-1821)

Cosway is the best known of the outstanding group of British miniature portrait painters active at the close of the eighteenth century and the beginning of the nineteenth. He works in full watercolor and body color on ivory, and also with pencil and watercolor washes on paper.

Self-portrait

Watercolor on paper; 4¾" × 3" (12cm. × 7.6cm.)

Acquired: 1927 (27.141)

Cosway presents himself in a fancy dress costume and an artful, studied pose. The idea of portraits in fancy dress, particularly dress of an earlier period, was popular in eighteenth-century England. Cosway has on the type of ruff collar, plumed hat, and puffed sleeve that belong to early seventeenth-century Europe, the period of Rubens and Van Dyck, one hundred and sixty years before Cosway's self-portrait. Cosway intended us to make this connection, and he hoped that some of the awe and respect we give to Rubens and Van Dyck would rub off on him. This appeal through association and allusion is central to much late eighteenth-century art. It was, for instance, utilized by Gainsborough and Reynolds in their famous portraits, *Blue Boy*, and *Mrs. Siddons as the Tragic Muse*.

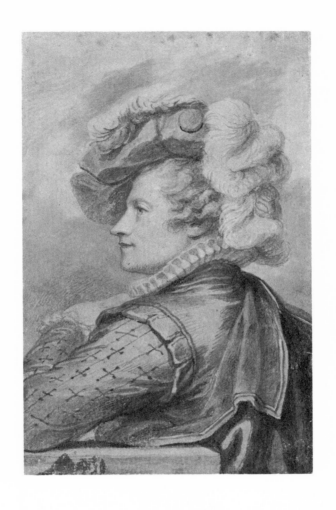

16. **John Smart** (1742/3-1811)

Smart now ranks with Cosway at the head of the group of miniature portrait painters active in the decades around 1800. Like Cosway, Smart produced full watercolor and body color miniatures on ivory as well as pencil and wash miniatures on paper.

Captain Pulteney Malcolm

Pencil, black chalk, and gray wash on paper;
6″ × 5½″ (15.3cm. × 14cm.)

Signed, inscribed, and dated: John Smart delint./Captn Pultney [sic] Malcolm of/the Donegal 1809

Acquired: 1963 (63.52.235)

Captain Pulteney Malcolm, later Vice Admiral Sir Pulteney Malcolm, had a distinguished naval career during the Napoleanic Wars. He was married in the year Smart drew his portrait. Perhaps this portrait was a present to his bride.

In this drawing Smart continues the tradition of the miniature plumbago portrait, which first appeared in England about a century and a half earlier (see Loggan, no. 3 and Forster, no. 5). Smart is fully the equal of his predecessors in the precision and exquisite detail with which he sets down the features. In this respect he differs from his contemporary, Cosway, whose touch is freer, with a corresponding lighter and airier effect.

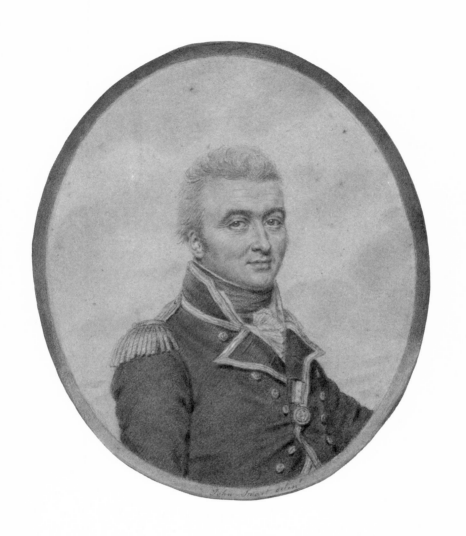

17. **Daniel Gardner** (1750-1805)

Gardner was a popular portraitist working in pastel, body color, and oil, or various combinations of the three.

Portrait of a Man

> Pastel; 10⅜″ × 8⅛″ (26.4cm. × 20.7cm.), oval
>
> Acquired: before 1960 (60.22)

Like Greenhill (no. 4) a century earlier, Gardner uses a limited range of color: black, shades of gray, red, blue, white, on buff paper. Also like Greenhill, he applies the chalk lightly, allowing the paper to show through here and there, retaining a sketch-like airiness of effect. Perhaps there is a little richer use of shadows on the face in the later work, encouraging us to speculate more on expression and character. Perhaps Gardner's man seems a little more relaxed and approachable than Greenhill's aristocratic lady. But generally one is more impressed by the similarity and continuity in technique over a century of time than by the differences.

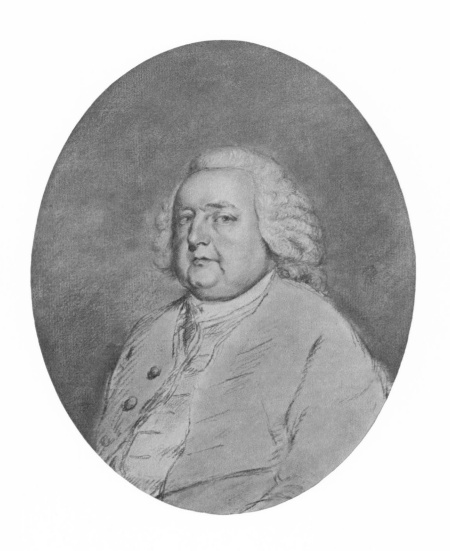

18. **John Downman** (1750-1824)

Downman was a prolific and distinctive portrait draftsman.

Mrs. Croad

Pencil and black stump, the cheeks touched with red chalk; 11¼" × 8⅞" (28.6cm. × 22.5cm.)

Acquired: 1958 (58.17)

Note: The drawing comes from volume 5 of the 4th series of "Original First Studies of Portraits of Distinguished Persons by Jo Downman" (See Dr. Williamson, John Downman, A.R.A. His Life and Works, *London, Otto Limited, 1907, p. 1x). In Williamson's book Mrs. Croad is described as "The Determined Widow," and the drawing is dated to 1806.*

This preliminary sketch for a more finished portrait has a breadth and vigor that is often smoothed away in the drawings Downman worked up for presentation to the sitter. The contrast between the freedom with which he suggests the drapery and the relative precision and delicacy with which he delineates the face occurs in the work of many other portrait draftsmen around 1800.

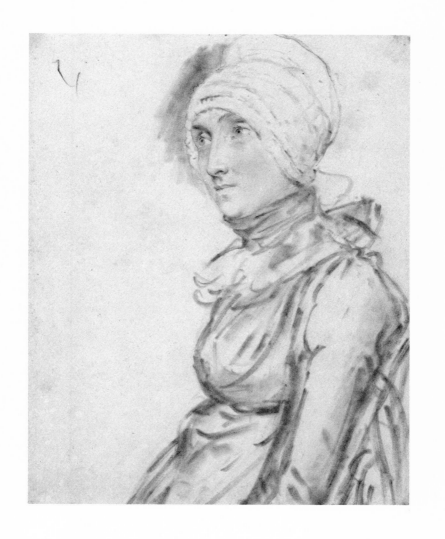

19. **Sir Thomas Lawrence** (1769-1830)

Lawrence was the leading British portraitist of the Regency and reign of George IV.

Mrs. John Allnutt

>Black and red pencil; 8¾″ × 7⅛″ (22.2cm. × 18.2cm.)

>Acquired: 1959 (59.55.803)

Elizabeth, daughter of John Douce Gaethwaite, married John Allnutt in 1796. She died in 1810. The drawing dates from the late 1790s.

Lawrence's portrait drawings, even more than his paintings, are an epitome of English Regency society: elegant, urbane, polished, superficial. He follows a formula for portrait drawings widely practiced at the time – working up the head in considerable detail; sketching the rest of the figure much more broadly. The use of red pencil in combination with black (another practice common among his contemporaries) adds decorative appeal.

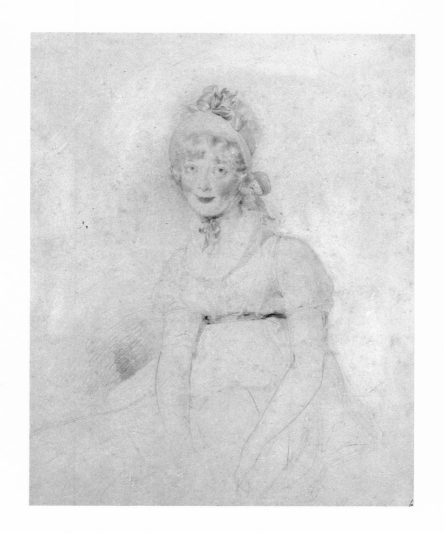

20. **George Henry Harlow** (1787-1819)

Harlow was a gifted, short-lived painter whose portrait style was based on Lawrence.

Mrs. Siddons as Lady Macbeth

> Black and red pencil; 9″ × 7¼″ (23cm. × 18.5cm.)
>
> Signed with initials: G.H.H.
>
> Inscribed: SS [presumably for Sarah Siddons]
>
> Acquired: 1968 (68.34)

According to information supplied when this drawing was purchased, it was made on December 13, 1813. This date cannot now be confirmed. At least one other version of this drawing exists, in the collection of Mrs. Siddons Budgen.

Sarah Siddons, the greatest actress of her day, formally retired from the stage on June 29, 1812, playing the role of Lady Macbeth. She made later incidental appearances, including performances as Lady Macbeth on June 11, 1813 and November 18, 1815.

In this portrait drawing Harlow uses precisely the same technique as his mentor, Lawrence. It is an elegant drawing, but the execution, particularly of the drapery and the hands, lacks Lawrence's finesse in depicting detail, textures, and the third dimension.

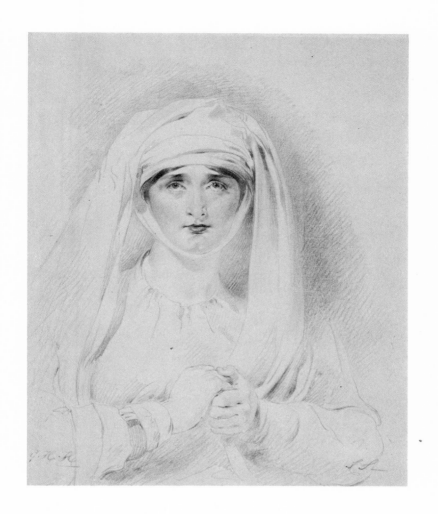

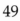

21. **James Smetham** (1821-1889)

Smetham was a painter, printmaker, and author. He was befriended by Rossetti, Ruskin, Madox Brown, all of whom praised his work highly; but he never received any popular recognition.

Portrait Study (probably a self-portrait, with a sketch of Rossetti).

Pencil; 11¼" × 7⅞" (28.6cm. × 20cm.)

Acquired: 1967 (67.35 D)

This haunting portrait has an uncompromising directness that is very rare before the mid-nineteenth century. Many earlier artists were concerned with representing detail meticulously. But they gave the face a more genial, more powerful, or more intellectual expression. Smetham shows the sunken cheeks, the sullen mouth, and the fixed stare of a man unwell and unhappy.

The drawing is interesting technically. The modeling of the face is developed by carefully controlled crosshatching, which reminds us that Smetham was a printmaker. It is a technique that gives the impression of more detail in the description of the textures and contours of the face than is actually there.

The profile sketch of a man in the upper right corner cannot be definitely identifed. But it certainly resembles Dante Gabriel Rossetti who is known to have been a friend and admirer of Smetham.

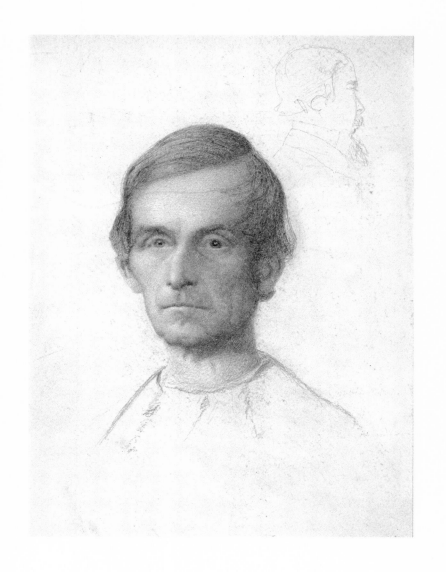

22. **Dante Gabriel Rossetti** (1828-1882)

D.G. Rossetti was a painter and poet, and a dominant member of the Pre-Raphaelite brotherhood.

Head of a Young Woman (probably Aggie Manetti)

Pen and brown wash; 6″ × 4″ (15.3cm. × 10.2cm.)

Acquired: 1972 (72.36)

According to William Michael Rossetti, Aggie Manetti was a Scots woman "of no rigid virtue who had a most energetic as well as beautiful profile." She was used by D.G. Rossetti as a model in the early 1860s.

Rossetti's portrait drawings, especially of women, are an instance of the predilections of the artist modifying what he sees. Or perhaps Rossetti sought out women as models who conformed to a particular idea he had in mind. In either event, most of Rossetti's female portraits are of women with heavy jowls, widely spaced eyes, and thick, luxuriant hair. All his women have a distinct family resemblance in features and a mildly sulky expression. One suspects this uniformity comes primarily from the personality of the artist. Every artist inevitably imprints some of his own personality on the portraits he paints. Rossetti is more emphatic than most in this regard.

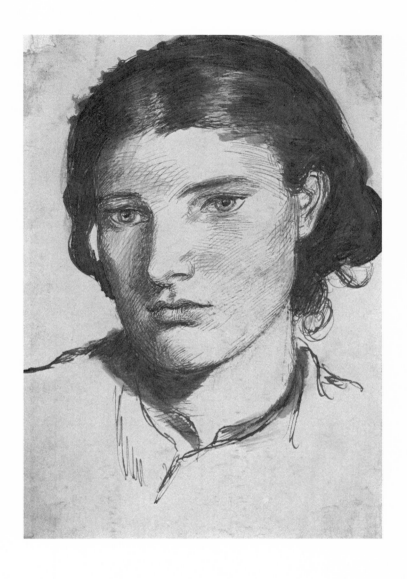

23. **Edward Thompson Davis** (1833-1867)

E.T. Davis was a short-lived, little-known, but highly competent watercolorist.

Head of a Girl

> Watercolor over pencil; 7¼″ × 6½″ (18.4cm. × 16.5cm.)
>
> Signed twice and dated: 1855/E.d./E Davis
>
> Acquired: 1963 (63.52.62)

The pure watercolor, which reached such dazzling heights in English nineteenth-century landscape painting, is less conspicuous in portrait drawing. The precision required in capturing details of a particular face can be better achieved with at least a linear sub-structure establishing the individual features. Such a sub-structure does exist in this charming portrait study by E.T. Davis, but most of the head is developed in pure watercolor with no evident underlying pencil or pen lines.

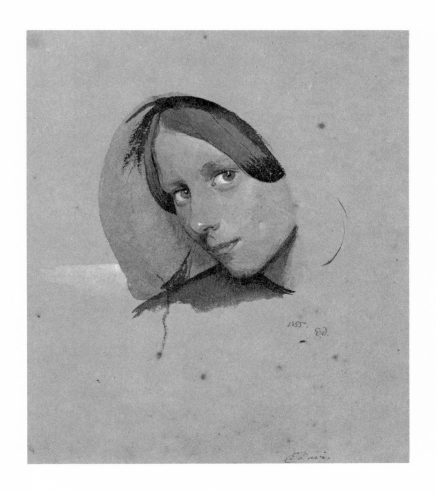

24. **William Henry Hunt** (1740-1864)

Hunt was an accomplished watercolorist who devoted himself in his later career primarily to genre scenes and still life. He used a mixture of watercolor and body color which gives his work luminosity and richness of surface.

Mr. and Mrs. John Curteis

Watercolor and body color:
(a) 15⅜″ × 11¼″ (39.1cm. × 28.7cm.)
(b) 15¼″ × 11″ (38.7cm. × 28cm.)

Each signed: W. Hunt

Acquired: 1959 (59.55.737 and 738)

Note: Hunt exhibited (a) at the Old Water Colour Society in 1843 under the title "An Interior in Devonshire Place"; (b) he exhibited in 1848 under "An Interior at the Residence of John Curteis Esq., Devonshire Place." Probably both date from 1842.

We do not have much documentary information about Mr. and Mrs. Curteis. Nor does Hunt give us a detailed account of their facial features. But he tells us a fair amount about their interests and circumstances by presenting them "at home." Both are shown in prosperous, upper-middle-class rooms with mid-nineteenth-century interiors in their house in Devonshire Place, London. Mr. Curteis reads a newspaper with several works of art behind him, including copies of recognizable paintings by Raphael, Titian, and Caravaggio. Mrs. Curteis reads a book in front of a well-stocked bookcase.

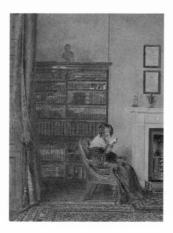

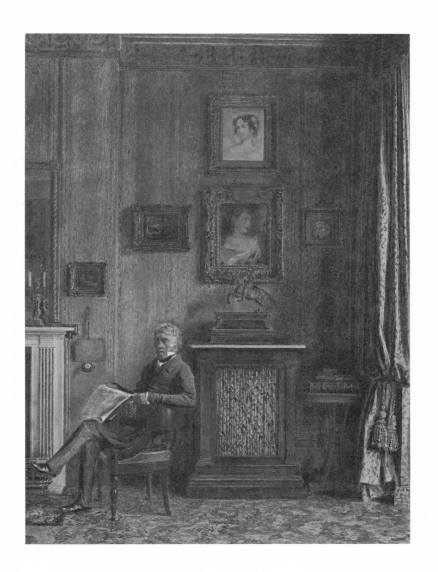

25. **George Richmond** (1809-1896)

Richmond in his early years was a friend and follower of Blake. Later he became a successful fashionable portraitist working as a miniaturist, a watercolorist, and in oil.

Lady Emerson Tennent

> Watercolor over pencil; 9⅝" × 7¾" (24.5cm. × 19.7cm.)
>
> Inscribed: Lady Emerson Tennent
>
> Acquired: 1959 (59.55.1058)

Sir James Emerson Tennent (1804-69) was a traveler, politician, and author. He married in 1831 Letitia, only daughter of William Tennent, a wealthy Irish banker, whose name he assumed.

The portrait is an excellent example of Richmond's virtuoso control over the watercolor medium. The dress and drapery he paints with dash and economy. He treats the face in a different manner, painting much more lightly and using a delicate crosshatching reminiscent of contemporary miniature portraits. Richmond is probably the most successful of British watercolorists in transposing to portraiture some of the brilliance achieved by landscapists in the handling of that medium.

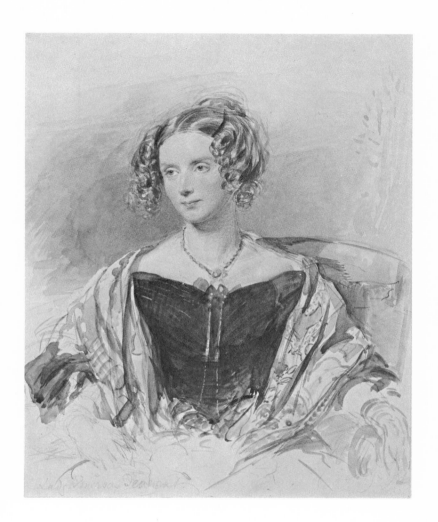